A GUIDE
TO
CAMEROON ART FROM THE COLLECTION OF PAUL AND CLARA GEBAUER

Portland Art Museum
Portland, Oregon

October 30 - December 1, 1968

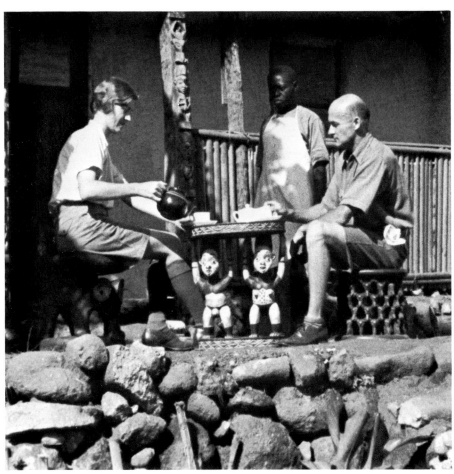

Northern Area Clara and Paul Gebauer at breakfast in front of their home among the Kaka people, 1936. (Posts, stools, and table were presents made by chiefs of the Bamenda Highlands, where the Gebauers lived before moving north.)

FOREWORD

Paul and Clara Gebauer have brought to their collecting a remarkable combination of qualities, not the least of which is the absence of that single-minded acquisitiveness that has built (one must admit) many superb collections. Other considerations were more compelling for the Gebauers who found themselves (from 1931 to 1961) amidst a people in the troubled process of radical social and economic change; amidst an art which was rapidly losing its traditional reasons for being. Dr. Gebauer was a missionary in Cameroon under the auspices of an American Baptist missionary society. He is also an anthropologist, having his M.A. degree from Northwestern University, and has a number of scholarly publications to his credit. He was made an officer of the British Empire by Queen Elizabeth in 1957. Mrs. Gebauer is an artist and teacher, a graduate of the Chicago Art Institute. She has developed a deep and sympathetic understanding of the Cameroonian art forms, bringing both sensibility and discrimination to their collecting, as well as to their work with the native artists—activities which were, of course, much interwoven. As it happened the families of both Paul and Clara Gebauer had connections with the Cameroons. So their background and their long and close involvement with the people gave them an almost unique preparation for assembling what has become a major American collection of West African art. Dr. Gebauer is presently chairman of the Department of Modern Languages at Linfield College.

During the many years they were in Cameroon, they did much to encourage native artists to continue their efforts—especially in wood and brass-casting—opening up new objectives in the hope of keeping alive their remarkable art abilities as the old meanings, the old motivations faded. Photos of their house in Kakaland show that they lived surrounded by Cameroonian-made objects for use or decoration, either given by the makers, or purchased or commissioned by

the Gebauers. The extraordinary leopard table in the exhibition was used for a time as a communion table. Masks were rescued one by one as they were discarded by the Cameroonians after their supernatural powers had, for one reason or another, fled. In such ways this remarkable couple preserved the objects, many of which you will see in this exhibition, and encouraged the artists to keep on working and the young to master the traditional art skills.

Like all collectors, the Gebauers enjoyed owning and living with the objects they were bringing together; but their first consideration was the preservation of the works—as records of a culture, as objects of art—which would otherwise have disappeared. And, secondly, they were conscious of the importance of their collection of this vanishing art, and planned that it should not remain a private possession but should eventually be widely shared—easily available both to scholars and to the public.

The Portland Art Museum is honored to be presenting the collection, virtually in its entirety, for the first time. The Trustees join me in thanking the Gebauers most warmly for this opportunity. We regard it as a happy circumstance that Professor Gebauer has returned to his Alma Mater, Linfield College in McMinnville, so near to Portland and its Art Museum where many thousands may enjoy this major collection at its first showing.

Francis J. Newton

INTRODUCTION TO THE COLLECTION

Some Notes on Cameroon
and its Art

by Paul and Clara Gebauer

Preface

The arts of Negro Africa were not accorded a place among man's great cultural achievements until the turn of the century. European artists were aware of the esthetic qualities in Negro sculpture as early as 1905 but the world in general gave it limited attention. A few early explorers, ethnographers, and missionaries of the last century recorded their personal reactions to this powerful and little known art but the objects they collected seemed to drift into curio shops and museums as ethnographic artifacts rather than as art objects of highly developed cultures. Much has been learned since 1900 about the art forms of the African to whom art is not only an expression of beauty but a communication and a release of deep emotion.

One African art form, Negro sculpture, is now accepted as an indisputable contribution to the cultural heritage of mankind. In the lands between the Sahara and Kalahari, between the Atlantic and the Indian oceans, artists have toiled thousands of years to develop the expressions we admire today. Anthropologists have traced broadly the major art areas and current research is subdividing regional concepts and styles, analyzing art forms, and establishing the history of Negro art. Best of all, modern Africa is developing a justifiable pride in the accomplishments of her ancient past.

This exhibition is limited to one major art area, Cameroon, and it emphasizes one art form, sculpture. All the pieces were collected by us during our thirty-odd years of missionary work in Cameroon. Recognizing their artistic value and being deeply concerned lest they be lost through the ravages of time, climate, and social and political changes, we brought them home. Many pieces were given to us in return for services rendered or as expressions of friendship. Many were literally rescued from termites and ridicule. They have become

a part of our lives. They remind us of a happy and meaningful association with a delightful people.

This guide to the exhibition is a condensation of the documentary material gathered by us. The photographs stress the indigenous setting of the objects here on display. Unavoidable ethnic nomenclature is reduced to a minimum here for the sake of those whose acquaintanceship with Negro art is limited. It is our hope to awaken in the uninitiated an admiration and concern for the people who developed this art, and perchance, a deeper understanding of our fellow Americans who once called Africa their home.

Some years ago a chapter of the American Association of University Women initiated the idea of a display at the Art Museum, of these things we have lived with so long. We acknowledge our indebtedness to them, to Dr. Francis J. Newton, Director, to Curator Rachael Griffin and the members of the Museum staff who have become friends since that first small exhibition. Without their personal enthusiasm and active support the present exhibition could not have been realized.

C. and P. G.

Linfield College
McMinnville, Oregon
September, 1968

About Cameroon orthography: Considerable inconsistency exists about the orthography of ethnic terminology. The German regime introduced a variety of prefixes for tribal names. British and French tendencies favored differing approaches. The bilingual policy of the present national government accepts the latest English usage for West Cameroon terms and the French orthography of 1960 for East Cameroon. The official yearbook of the Federal Republic for 1968 illustrates the present policy. It is followed closely in this guide.

CAMEROON

Geography Cameroon occupies the most beautiful and most strategic sector of West Africa. Where the coastline takes a sudden right-angle turn toward the equator, there Cameroon holds 250 miles of surfbound beaches along the Gulf of Guinea. At its southern point the border turns east and inland for 450 miles to form the base of an elongated triangle, the apex of which rests in the shallow waters of Lake Chad. The eastern border follows river courses. A chain of mountains determines the western frontier. This chain begins at the Atlantic coast with Mount Cameroon, an active volcano of 13,358 feet, and runs northeast, reaching several inland heights of 8,000 feet to terminate in the Mandarra hills near the Chad.

The land area of Cameroon is about twice that of Oregon. Five geographical divisions are observable. The rain forest of the coast reaches a hundred miles inland in some areas. It contains unspoiled tropical growth and includes the wettest spot on earth. The southern region consists of tropical forest, farmland, and plantations at an elevation of 1,500 feet. The eastern highlands average 4,500 feet. They are inhabited by fascinating tribes and small nations. The thinly populated central plateau offers the nomadic Fulani extensive grazing grounds for their cattle. The northern savannah contains the Benue and Chad plains of parkland and steppe.

History Cameroon has been inhabited for a long time. Numerous are the artifacts and toolmaking sites of stone age man. Traces of the bushmen are in evidence and remnants of pygmies dwell in the rain forest to this day. The histories of present tribes tell of prehistoric populations they displaced or absorbed. Latest theories consider the Cameroon grassland as the original home of the Negro. Historic certainty begins with the Sao people who arrived in northern Cameroon during the tenth century and developed an interesting culture that lasted four centuries. Invaders from east and northeast displaced the Sao culture in the fourteenth century; successive waves of migrants, pressing north to south and southwest, settled on the central highlands and invaded the forest areas. They remained undisturbed by the outside world and developed their culture in relative peace until the fifteenth century.

The earliest outside contact may have been a visit by seafaring Carthaginians in the fifth century B.C. Certainly the Portuguese of the

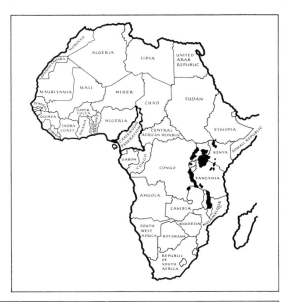

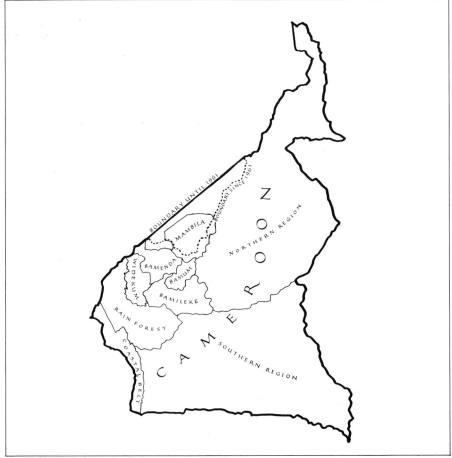

fifteenth century established the first European contact with the coast. An abundance of crayfish, mistaken for prawns, led the explorers to name the coastal estuary Rio dos Cameroes. The Spaniards renamed it Rio de Camerones. British traders and missionaries derived "Cameroons" from the Spanish name. The Germans applied "Kamerun" to the entire hinterland up to the Chad. The French spelled it "Cameroun." The present government, with its bilingual policy, adopted Cameroun and Cameroon.

Cameroon experienced three types of colonialism. From 1884 to 1915 Imperial Germany ruled the land. Allied victory in 1915 brought about a French mandate over four-fifths of the area and a British mandate for the rest. The United Nations Organization of 1946 established trusteeships which had independence of the territories as a final goal. East Cameroon achieved independence on January 1, 1960. Unification of the two Cameroons occurred October 1, 1961, and marked the beginning of the Federal Republic of Cameroon. The Republic ranks high among the independent nations of Negro Africa.

Crossroads Cameroon is the crossroads of West Africa. The western mountain chain acts as the great divide between north and south, east and west. Four watersheds meet in the center of the land, dividing the climate and the flora and fauna. The five million inhabitants within the three great language families meeting at the crossroads present a very complicated ethnic configuration. Almost 150 distinct languages are recognized and among the one million West Cameroonians alone exist sixty-five distinct ethnic clusters. Racially speaking one meets every type of Negro, racial remnants of prehistory, and Semitic strains of recent centuries. Here is the last hunting ground for the social scientist.

The ever changing fortunes at the crossroads produced a delightful mixture of physical types. The uncertainties of life favored the development of common characteristics. Cameroonians are extraordinarily friendly, hospitable, and industrious. They are keen observers. Swiftly they adapt themselves to changing situations because survival is in their bones: subsistence farming is giving way to modern economic measures; the plantations of colonial years have been nationalized. These, and modern cooperatives, account for 60% of the total exports in the form of coffee, cocoa, rubber, bananas, palm oil products, cotton, tea, and peanuts. Favored by abundant water power, industrialization progresses rapidly. Cameroon is booming.

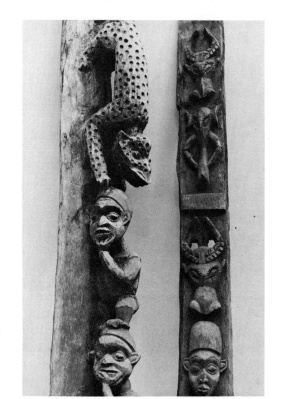

Bamenda Highlands. Two carved house posts, (Left) Bakani Group, from a Court House. Sacred leopard and court messengers. (Right) from a clubhouse at Babanki, from top: buffalo, elephant, buffalo, head.

Bamenda Highlands The old clubhouse of the Ruler of the Bali people.

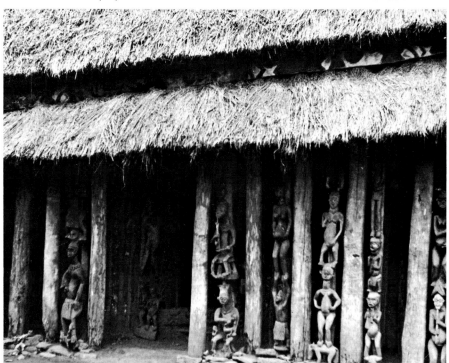

CAMEROON ART

Art Forms

The present economic boom is nourished by a peculiar spiritual dynamism. The evidences of this hidden power are apparent in every art form of the land. Art expressions may vary sharply but a common forceful rhythmic drive permeates all of them. In the Cameroonian scale of art forms the dance ranks highest, followed by music and oral verbalization. The latter form, not as recognized in western culture, is indispensable to preliterate societies where the power and beauty of the spoken word is displayed in storytelling, oratory, proverbs, riddles, and poetry. Third in importance to the Cameroonian is body beautification, now rapidly disappearing. Next comes indigenous architecture as a true expression of the spirit of a culture and an age: the dome-shaped grass shelters of the Bororo vie with the famous cone-shaped clay houses in the Chad Plain. Rectangular huts with gabled roofs prevail in the forest. In the grassland square, tall houses with roofs in pyramid or round form predominate. The round huts and pointed round roofs of the Mambila match the beauty of much contemporary architecture that has made use of similar forms. Painting receives limited attention, but charcoal, kaoline, ashes, laterite, and powdered camwood serve as paints in wall decorations, which favor geometric design and figure drawing. In the Bamileke and Bamum areas wall paintings maintained some popularity up to recent years.

However, it is in sculpture (not high on the Cameroonian scale) that we meet the greatest variety of expression and find so much that is of the first quality. While viewing the sculptured objects of the exhibition it is well to remember the importance of content to the Cameroonian. The dynamic *function* of the object is primary, its form secondary. All of the carved pieces were means of placating spirits, means of controlling anxieties. Preliterate life was not an easy one. Spirits and ancestors had to be kept at beck and call for instant assistance. Suitable dwelling places were provided for them in these carvings.

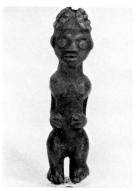

Bamenda Highlands Charm carved wood, 42.

Bamenda Highlands Bobe Anyadjwa and the emblem-charm of
his office as the Keeper of the Valley

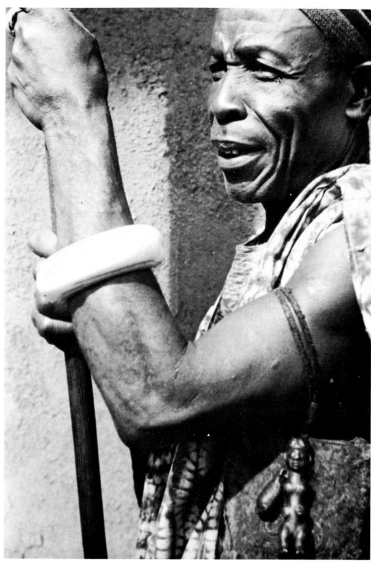

The aforesaid does not dismiss form. Tradition controlled rigidly the transformation of human and animal likenesses into patterns of geometrical abstractions. Tradition dictated proportions, distortions, and time-tested emphasis on essentials. Form is important but not to the extent that our western concepts would have it. For this reason western critics are often at a loss about these objects. They refer to them as "sacred or secular art," as "geometric magic," as "spiritual passion captured in sculpture." All of these terms are acceptable but somehow miss the mark. We of the west remain strangers to the religious emotions and convictions that inspired this art. We continue our search for some all-embracing term we shall never find.

We are on more familiar ground with reference to one special category, namely royal art. The principle of divine kingship still is alive in the grassland. Sacred are the symbols of a ruler's authority, such as staff, fly whisk, cap, stool, and ornaments. Sacred are his personal belongings such as palm wine cup, tobacco pipe, snuff box, and charms. His bedchamber furnishings abound in sacred symbolism. His wives, retainers, messengers, and their households, wear these insignia as a mark of their connection with the Court. It is understandable that the noblest products of the crafts are found in royal households.

ART AREAS
The Coast

For a better understanding of the material and as a transitory measure of convenience one may subdivide the Cameroon into art areas. The coastal belt is commonly classified as one sub-area. Its ethnic groups have been influenced by prolonged contact with the outside world. Its art forms naturally have the flavor of life by the sea, as for instance the Duala with their highly ornamented canoe prows, paddles and ceremonial stools. Western carpentry and commercial interests brought carving to a standstill around 1900. The present objects of the Duala, made for the tourist trade, are far removed from traditional standards.

The South

The southern region with its Bantu concept of vital force developed finely executed figures and masks. Their relationship to Gabon and Congo art is obvious. Many of the reliquary figures labeled as "Fang" by collectors and museums originated in this southern region. The features of the seated guardians of the ancestral bones are well known. The art style of this once rich region succumbed to European innovation before the turn of the century.

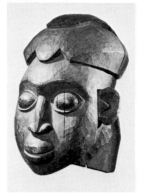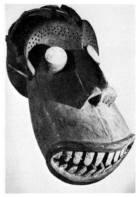

Bamenda Highlands Helmet Mask, Kom Group, mask of a Veteran's Society, carved wood, 220.

Bamenda Highlands Helmet Mask, mask of the Manjong Society of a Fungom Group of Elders, carved and painted wood, 87.

Bamenda Highlands Kom Group. Gathering of masks at the funerary rites for the late Fon Nsi, paramount ruler of the Kom people.

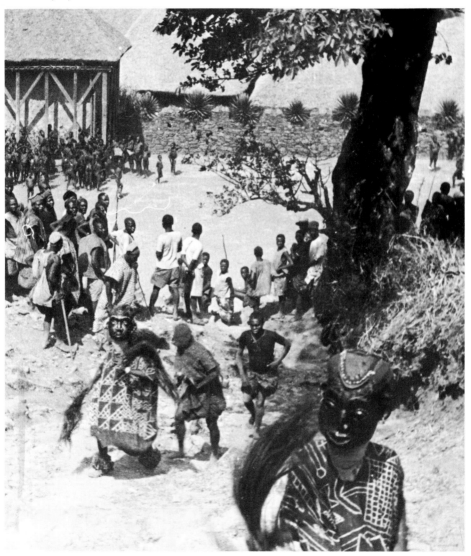

The Rain Forest The anthropomorphic and zoomorphic masks of the rain forest region reflect the mysteries and fears of life in the primeval environment. Influences of the Ekoi culture of neighboring Nigeria cannot be denied. The skin-covered face masks and headgear of the Banyang represent a marked departure. Geometrical abstractions help create awe in the beholder. Here are the prototypes of modern art expressions of the western world. The rain forest region continues to produce a few masks and figures, the most unique being the jointed headgear figures. But the art of the rain forest began to decline early and has almost disappeared.

Widekum In the Widekum migration area we meet styles that fuse rain forest mysticism with grassland concepts of power. The skin-covered masks of the forest appear more friendly. The jointed figures acquire more northern features. The social aspects of cult objects receive a strong emphasis. All art styles of this region reflect the social and political processes of diffusion of cultures.

Bamileke The well-documented Bamileke area embraces almost a million people. Most characteristic are the carved posts of the palaces, the door-frames and huge standing drums of the shrines. Totally new are masks made of textiles and fibers. Out of the concept of the elephant totem, the Dschang evolved a unique cloth mask of richly colorful applique and embroidery. The long swaying trunk and ears heighten animation when used in the dance. The political unrest of the past decade destroyed much of the remaining evidence of this monumental art.

Bamenda In the Bamenda highlands the symbolism of totemism and fertility rites plays a prominent role. Sculpture in the round reached its height in the powerful masks, royal stools, and carved posts of lodges and shrines. Designs are strong and forceful in their simplicity. Quite different in feeling from other areas, they are less grotesque, even radiating a delightful charm. The feudalisms of the so-called Tikar groups protected traditional styles and made every palace an art museum. Royal and domestic arts filtered down into the daily life of the common people. The little food bowls illustrate this. Many pieces of this exhibition come from this region. Feudalism has had its day here, and with its disappearance go the crafts and craftsmen of an art-loving people.

Bamum Wedged between the last two areas there is a small, important nation,

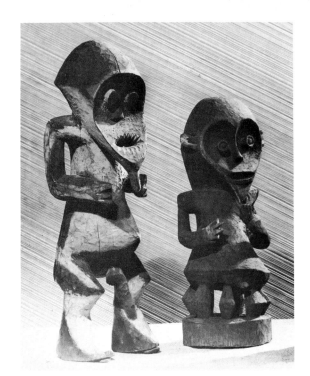

Northern Area Two Guardian Figures, carved and painted wood, 233, 78.

Mambila Area The Keeper of the family shrine at Barrup.

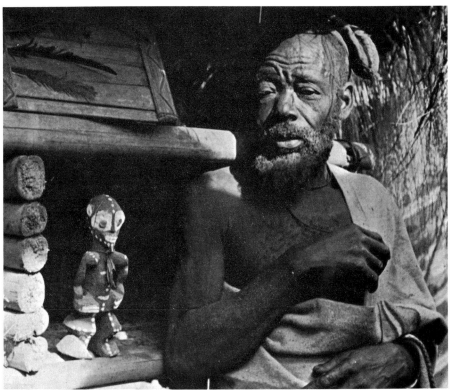

the Bamum. Among these people a charming blend of art traditions has been achieved. Bamum area is the best known of all sub-areas. The late King Njoya helped his craftsmen achieve perfection of form and style long before the Europeans entered the kingdom. He maintained two museums. His patronage developed an art appreciation among his people not found elsewhere. Characteristic of the Bamum is their bead-covered sculpture. This added color and design to an essentially strong base that actually required no additional adornment. In metal sculpture the Bamum display their traditional directness. They learned the lost-wax method of casting from a Tikar group. They mastered the craft, perfected the designing of the wax models, and eliminated competition in this field. The Bamum casts became and still are excellent examples of lost-wax casting.

Mambila

North of the Bamenda highlands lies the Mambila plateau, an isolated land of indescribable beauty. Its 30,000 inhabitants have developed a style which a hundred years of subjugation to a Fulani rule has not extinguished. The Mambila alone of all the sub-areas made extensive and effective use of pith for sculpture. These dramatic little figures do guardian duty at the shrines. The predominance of heart-shaped faces in the figures of wood and clay would presume an ancient origin of style. The Mambila custom of repainting all objects before each public appearance does not help the work of the historian. The Mambila monopoly in pith sculpturing adds to the problem of origin of this art form since raffia-pith is available in all other areas. The pieces on exhibit come from our early contacts with these people. The plebiscite of 1961 incorporated the Mambila plateau into Northern Nigeria.

North

The northern sub-area (a very tentative classification) covers geographically the central plateau, the northern savannah and the Mandarra hills. The Fulani conquest in the early years of the last century gave these areas an Islamic flavor. Beneath it exist islands of indigenous cultures. Future research will add others to the presently known names such as the Babute, Chamba, Kentu, Kirdi, Mbam, Mbembe, Mbum, Mfumte, and Tigong. The splinter groups between the Mambila and Bamoa plateaus are included here. Fulani warfare separated them from unknown parent stock in the north. Along the headwaters of the Donga River, protected against Fulani horsemen by inaccessible terrain, they managed to preserve their culture. For their art styles we retain the term ''Kaka''—possibly a nickname applied to them by their enemies.

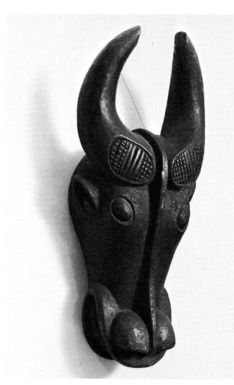

Bamileke Area Buffalo mask of the Hunters' Society, carved wood, 304.

Widekum Area Dancers in the Mameta market place.

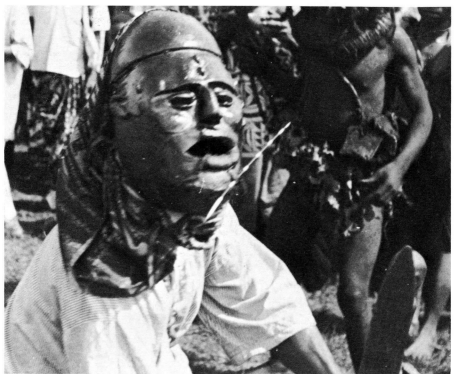

**Cameroon Art
Characteristics**

An ethnologist of the last century spoke of Cameroon sculpture as "Bauernkunst." By this he did not mean that it is little more than peasant art but rather he wished to emphasize its essential earthiness and honest directness. The deliberate reduction to essentials, its "truth-in-form" if you wish, produced masks which need no commentary. The sculptor's unerring drive toward the essence of a thing is conveyed in the elephant mask, portraying powerful serenity; in the buffalo mask where one feels the vitality of the charging animal; in the moon-faced helmet mask which captures the quiet assurance of the man in authority. These artists understood the truth that "less is more." Their plain, strong, honest sculpture has a way of compelling response in the viewer. How much greater the impact then, while seen in action among throbbing drums and swaying bodies!

The relative isolation of Cameroon in our mid-century favored a strong control by tradition: details were standardized; guilds and public opinion guarded form and style through centuries. Yet within this seemingly rigid pattern individuality was permitted. Each cluster of craftsmen put its particular hallmark on its products. One may easily trace a wayward piece to its source by such traditional details as head proportions, leg positions, hairlines, eyes, lips, and method of surface treatment.

**Art and Artist
in Traditional
Society**

Traditional Cameroon society did not have to offer its youth special courses in art appreciation. The sum total of environment and society's way of life helped youngsters to an awareness of esthetic values. How could one escape the repetitive force of the tall post figures, or the symmetry of door frame reliefs, the power of dancing masks, or the gentleness of divination birds swaying in the evening breeze, the array of sculpture and color at the annual sacrifices—or the weekly display of skill in the market place? Society accepted only work by trained craftsmen and standards of good design were set by the guilds. This made for a discriminating public that did not hesitate to express its approval or disapproval of the work while in progress.

The artist held an honored place in this society. He was automatically elevated to the council of the elders. Some grassland tribes even made it a prerequisite for chieftainship since artistic talent was in itself a divine gift. Others organized guilds around outstanding masters. Often rulers drafted master craftsmen into their families, established them as court artists in residence to produce the royal art needed.

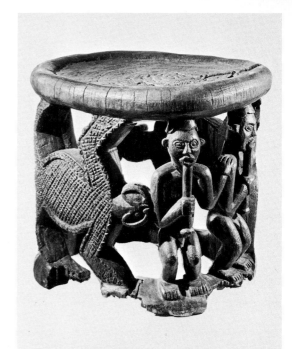

Bamum Area Stool with flute players and stylized leopard design, once the seat of a Judge among the Ndop peoples, carved wood, 387.

Mambila Area Flute players at the harvest festivals.

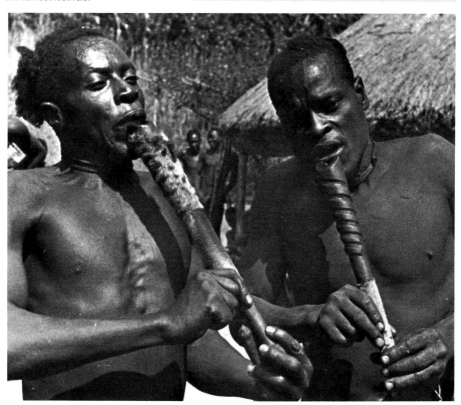

Some individuals, after completing the required apprenticeship, remained independent of royal patronage and guild protection and made their carving an avocation to be followed at leisure. In fact we knew of none who made their art a full-time profession. Now the socio-religious structure that made them is breaking up and this rare breed of individuals is disappearing.

The heartbeat of dynamic religion throbs in Cameroon art. Very much alive are the spiritual concepts of man and nature as embodied in this art. To define this pulsing life as "nature control" or "animism in action" does not wholly suffice. The sculpturing of these objects was serious business. The act of translating ideas about gods and vital forces into wood and clay was religion in action. Why do some of these appealing little figurihes look so lost and startled between museum walls? It is because their makers captured in them fleeting moments of mystery, of spiritual ecstasy and of sacred symbolism which are altogether foreign to their present environment.

A rhythmic harmony characterizes Cameroon art. Frobenius of old was moved by the dramatic, rhythmic qualities of the masks and monumental figures. These artists had a sensitive feeling for their medium and its relationship to form. They, like all artists, were temperamental and worked only when moved by the spirit. It was not uncommon for us to find artists at work to the accompaniment of musicians. Carvers even developed a rhythmic staccato to their chipping. The inward serenity witnessed in the faces of old craftsmen is reflected in the creations of their hands. Harmony within produced harmony without.

Lastly, Cameroon art is observable in some places to this day, continuing to function, though in a declining state in a few of the areas reviewed. Patrons and guilds might have vanished, but a few old sculptors still carry on. Due to drastic changes in the political structure of the land, secret objects, once kept away from the eyes of women and children, now make their appearance in public. A shift of emphasis from sacred isolation to public entertainment brought every type of mask into the open after 1960. Not so long ago high fees had to be paid in order to photograph a cult object in its indigenous environment. Ancient glory has departed.

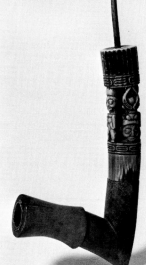

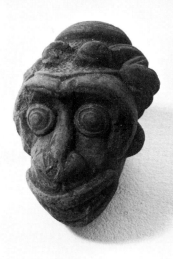

Bamenda Highlands
Pipe, wood bowl, ivory
and brass stem, 173.

Bamenda Highlands
Pipe Bowl, terra cotta,
proto type of the
Bamessing pipe
makers, 70.

Bamum Area Elder
in a market place.

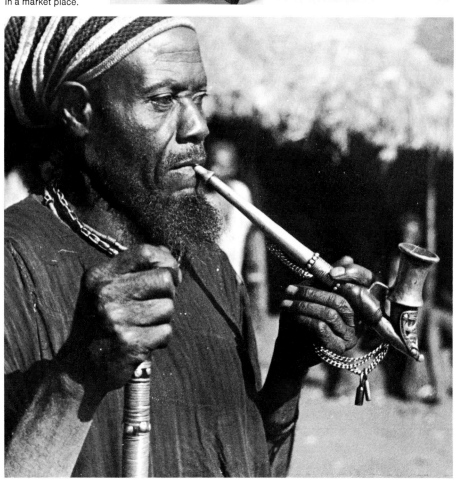

Art in Transition The art being produced in Cameroon in recent years may be called "transitional" since the old traditions have crumbled and a new art (which we confidently predict) has not fully emerged. Even in this tentative, transitional period, these talented people are able to adapt their traditional designs and skills to modern requirements. Such efforts began in about 1910 when household furnishings were made by the Cameroonians for German colonials. The so-called "Bali stools" of the Bamenda area originated in this period. They illustrate well the adaptation of traditional designs to modern needs and decorative objects. Under French influence the Bamileke carved wall plaques of native scenes to ornament homes of officials and government buildings. The Bangwa were encouraged to turn their traditional clay pipe-bowls into veritable pieces of wood sculpture. The Bamessi produced large glazed terra cotta figures which began to appear in the local markets. The Bamum guilds, catering to the new trade demands, produced neat little brass miniatures of native life and scenes. Hausa traders spread these wares into the coastal markets, where they were purchased by curio-hungry soldiers and visitors.

Art produced for the tourist trade was not necessarily poor art. Though lacking the force of religiously inspired traditional pieces, the early work was nevertheless often excellent in form and design. Between the two world wars a limited commercialism developed around this type of art. But the emancipation of the individual and his search for independent cash, the breakdown of guild sanctions permitting anyone who wished to carve, the increasing demands of a growing tourist traffic finally fostered mass production and a corresponding decline in quality. The end result of this trend, aptly called "airport art," is to be regretted.

Disturbed by this trend we began in 1932 our attempts to preserve the quality of traditional art by finding new outlets for art expression. We were able to engage master sculptors for the beautification of chapels and schools, for training promising students and for forming circles of young craftsmen. Opposed often and misunderstod more often, we nevertheless continued. We left behind the beginnings of a regional museum and in schools and churches are preserved the best of an art in transition.

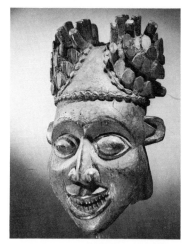

Bamenda Highlands Helmet Mask, Kom Society of Princes, carved wood, 85.

Bamenda Highlands Chief Vugha of Bakanki

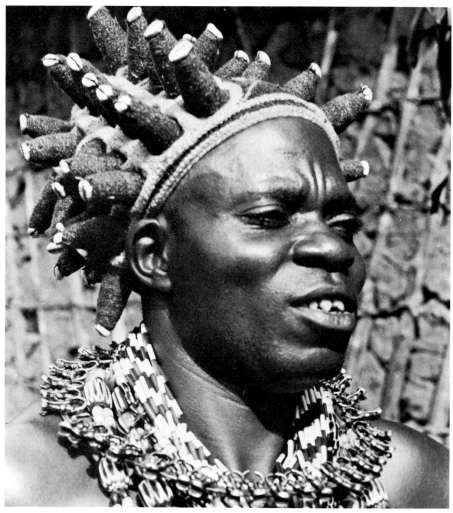

THE COLLECTION

The reasons for this collection and the ways and means by which it was brought together have already been stated briefly in the preface. We feel our training in art and anthropology respectively—and perhaps also the early interest in Cameroon by both our families—enabled us to observe with sympathy the culture behind this art and to participate with understanding in the life of the people who produced it. Having lived with this art as it functioned in its traditional environment we experienced personally its transformation from traditional to transitional art.

Through our advantage of having lived these many years in intimate association with these people, we were able to collect discriminately, piece by piece, as circumstances made works available to us. Aside from the esthetic value of the collection we hope it will fill in some of the gaps in existing literature on Cameroon. Literature in English on this specific area of Africa is understandably spotty. The British administered only a narrow portion of the land for only forty-five years, and that only as a questionable appendage to Nigeria. Lack of policy and funds limited research. In addition to our personal experience we have in our library much of the German material printed before 1915. We are acquainted with the French publications which naturally emphasized East Cameroon. We keep in touch with the latest Cameroon research through *Abbia,* the official cultural review.

We do not claim to be experts. We are trained amateurs who wish to share the pleasures of our past years. Time and tide may permit a more expanded account of all that we have gathered.

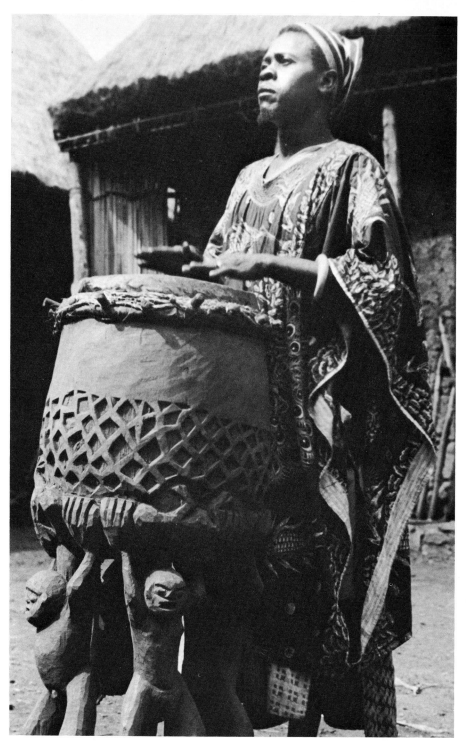

Bamenda Highlands The ruler's drum and drummer in the Balo Valley of Kom.

CAMEROON CULTURE
CONCEPTS AND TERMS

This exhibition deals with six of the art areas mentioned above. Though these areas are far apart geographically, they have in common certain basic concepts not found in our culture. To know something about them may provide a better understanding of the things on display. The following notes about some of the concepts and terms derived from them are offered in alphabetical order for your convenience.

Ancestor Cult The living and the dead of a group are one unbroken, functioning unit depending on one another for fellowship, guidance, and mutual support. Around this belief has developed an elaborate cult with its priesthood, shrines, objects, as well as rituals and duties such as homage, sacrifices, prayers and dances. One duty of the living — to provide shelter for visiting souls of the departed — accounts for a number of figures in the collection.

"Art for Art's Sake" "Art for Art's Sake" has no place in Cameroonian ideology. Every art object has an underlying meaning and significance. The importance of the symbolism and of ritual usage of the objects can never be overlooked; nor the belief in an all-embracing life-force, visible and invisible. These and other basic concepts are beyond the scope of this little guide. They must await attention at a later date in a more inclusive work.

Associations This general term covers more than the much popularized "secret societies." It includes secret and sacred associations of men and women, of age groups, veterans organizations, mutual aid societies, and all kinds of lodges. The limited value of the individual in traditional society plus the communal approach to all things supported a multiplicity of associations. Traditional society was highly structured.

Bamenda Highlands Seed basket, Wum Community, 26.

Bamenda Highlands Woman and baskets,
Bafut Group, basket on back: a chicken coop.

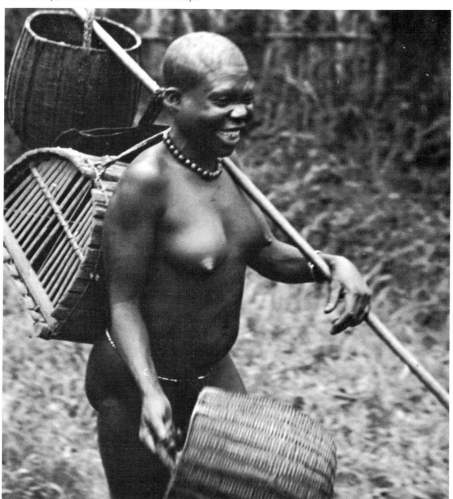

Bags	The bag is a necessity in a society not bothered with clothing. In the bag man keeps his most personal property: drinking cup, pipe, flint and iron, tobacco, cola nuts, and also his private charms and the tools of his calling. In a woman's bag one finds her cup, pipe, flint and iron, tobacco, snuffbox, cola nuts, comb and cosmetics.

The bag became a status symbol revealing by its material, quality and workmanship, its design and dimensions, the social position of its owner. Children receive their first small bag at initiation and the standard-sized one at maturity.

The craft of the weavers lost out to the imports of goods from Manchester and Paris. |
Basketry	Coiled basketry is a widespread craft. Each group has its traditional expressions and means of beautification. The simplest basket, the common covers and mats, have touches of design and/or color. The huge beerbaskets and palm oil containers are woven in geometric patterns. Imagination has turned the products of Wum society into things of beauty—and status symbols.
Camwood	Red is the sacred color among many inland groups. The core of a tree grown in the lowlands is beaten into a pulp, and formed into bright red balls and mixed with palm oil. These supply a permanent red color which is used very widely. Sacred stools, chiefs and their wives, brides and babies are frequently covered with this mixture to meet the requirements of ritual and social status.
Charms	They have a universal appeal and exquisite workmanship. The ivory charms once protected men of high office. Of the wooden figurines some performed double duty as badges of office and as protective devices. All of them once sheltered magical powers of one sort or another; some became useful medical tools in the hands of practitioners.
Coiffure	As a highly personal form of adornment, the arrangement of the hair received the deserved attention of women and men alike. The standardized coiffure of Bamum ladies appears frequently in Bamum casts and masks. The striations seen in Wum and Northern masks and figures

Bamenda Highlands The Chief of
the Babanki people.

Bamenda Highlands Charm, Ndop
Group, carved ivory, 36.

Bamenda Highlands Royal scepter,
carved wood head with copper
overlay, bead decoration, horse
tail trailer, 92.

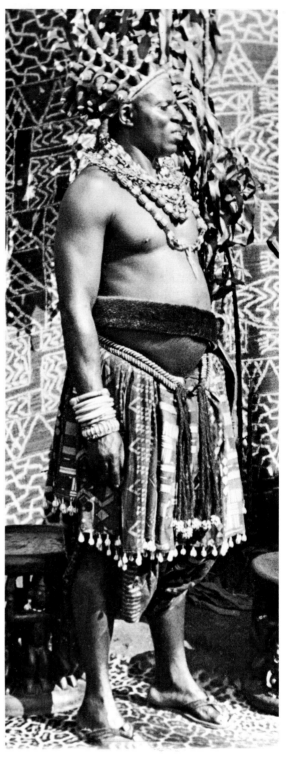

are presentations of the coiled, striated hairdos of local dancers.

Cola Cult The highlands abound in cola trees and their fruits are much desired on account of their caffeine content. But the chewing of cola nuts is more than a national pastime. The economy of certain groups once depended on the cola harvest. The height of hospitality is still expressed in the sharing of a cola nut and bridal wealth was once reckoned in cola trees. The wealth of some leaders was assessed by the cola loads his carriers took to the edge of the northern desert. A pact between lovers is sealed to this day in the solemn chewing of a cola nut. This colorful cult is now fading out.

Divination Man's attempt to ascertain and to control the will of the gods and the forces of nature receives much attention by a variety of means. The two bird figures are Cameroon parallels to the ancient art of augury—the observance of birds in flight. The frequent appearance of the earth spider symbol points to the once widespread use of the black earth spider in divination.

Divine Kingship The concept of divine kingship is much alive in the grassland, and numerous are the powers and prerogatives derived from it by past and present rulers. The pageantry of courts and certain rites are derived from sacred kingship. Royal art prospered within this framework but the import of western democracy is putting an end to it.

Feudal Order The forest area with its autonomous chiefs and strong village councils did not favor the building of large tribal and national organizations. The grassland, on the contrary, developed highly structured feudal societies under mighty rulers with political and social stratification equal to those of Europe's middle ages. Royal courts, feudal law and order, officialdom and guarded isolationism produced centuries of relative peace and prosperity in which the arts could develop richly, outstripping other regions.

Groups Used here as a generalized term of reference to any social or kinship grouping, such as the extended family, the clan, the so-called tribe.

Guardian Figures Quite a number of the figures, especially in the Mambila area, were "guardians of the shrine." Others performed a double assignment as

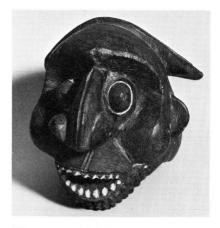

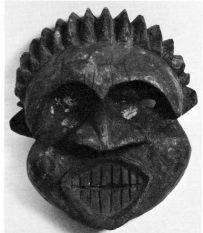

Bamenda Highlands Helmet mask, Isu Group,
carved and painted wood, 18.

Bamenda Highlands Helmet mask, Wum Group,
carved and painted wood, 17.

Bamenda Highlands Nsaw group

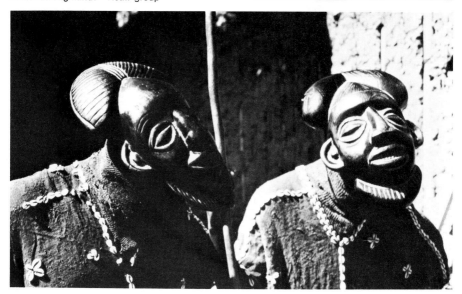

Quite a number of the figures, especially in the Mambila area, were "guardians of the shrine." Others performed a double assignment as memorials to an ancestor and as abodes for returning spirits. The guardian figures were not idols. None was worshiped. The libations poured on them were meant for the ancestors and/or spirits. The food particles tossed to them or pressed into the openings seen on some, were again meant for the indwelling or visiting spiritual beings.

These openings, cut into front or sides or back of some figures, may also have been receptacles for magical substances, prepared by the priests. Such figures were held in high regard for their metaphysical qualities.

Head

A widespread Cameroon belief that the head is the temporary seat of the soul spirit gives it great significance. Therefore the often disproportionate prominence of the head in carved images; therefore the social sanctions about the head.

Head Coverings

It is a privilege to cover one's head. Household slaves of the olden days were not permitted to do so. Free men, then and now, declare their social status by the type of caps they wear in public. Shape, size, symbolism of a cap indicate the wearer's clan, lodge affiliation, and socio-political position. Rulers, never seen uncovered, evolved for themselves elaborate headgear, rich in symbolism, towering above all others by use of a built-in frame. Masks and casts reflect the importance and variety of the royal crowns. The patterns in wood and metal cannot be interpreted otherwise. A gathering of masks can be as delightful to the eye as a gathering of the House of Chiefs.

Ivory

Forests, rivers, and the grasslands teemed with elephants and hippos until the flint-lock gun came within reach of the common man. The traditional rulers had priority in claiming all ivory, which was a most desirable trade item. Royalty alone could use it in the form of footrests, seats of judgment, as adornments of sacred places, and on their sacred persons. Ivory bracelets signified membership in royal households or national councils.

Lost Wax
Process

The lost-wax process of casting is now practiced in the Bamum area only. A form modelled in beeswax and coated with fine clay is translated into metal. The method requires a good deal of technical as well as artistic skill. Each article produced is in fact an original as it is

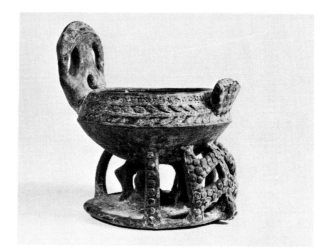

Bamenda Highlands Food bowl, Bamessi Group, terra cotta, 132.

Potter at work.

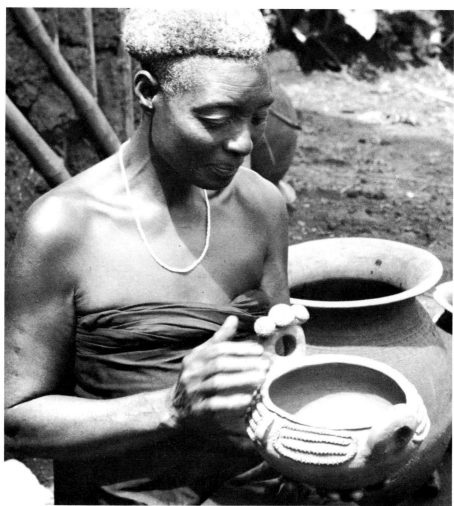

necessary to destroy the mold in order to free the casting.

Masks They were indispensable parts of the indigenous religion. As sacred masks they participated in the night scenes of sacred rituals; and they functioned in daylight during the annual festivals of atonement, seed-time and harvest. Most had secular duties such as maintenance of law and order, initiation and protection of sanctions, fire control and messenger obligations. They appeared on market days and in the common public dances to exercise social control.

All of them, sacred or secular, were considered living members of the group in which they functioned. They had their appointed keepers. They were bathed, oiled, painted or rouged before public appearances. Like human beings, they had their life cycles. With their owners, or keepers they lived, died, and were buried or forgotten.

By themselves these masks are dead wood to the Cameroonian. They need gown and dancer, music and a congregation to function properly, to be possessed by spiritual forces, to be really alive. They are now within these museum walls because they are dead and worthless to the original owners. The esthetic value we attach to them is a foreign idea in the traditional society in which they were made and used.

Palm Wine Cult Interesting beliefs about potency, hospitality, prosperity and magical communion exist in connection with palm wine, the national strong drink. The first sip of any cup is poured on the ground as a libation to the ancestors. All rites, all sacrifices, all medical treatment, all social functions require palm wine for completeness. This all-embracing cult includes palm groves, tappers, and tools. Again and again the cup appears among the sculpted objects, royal and domestic.

Pottery The seven little bowls came from the center of pottery at Bamessi in the Bamenda highlands. The finest clay deposits, the skill of the women and the nearness to an ancient trade road helped to dispatch Bamessi pots all over the interior.

Other areas have clay and made pottery, but none matches the perfection of the little palm oil bowls from Bamessi.

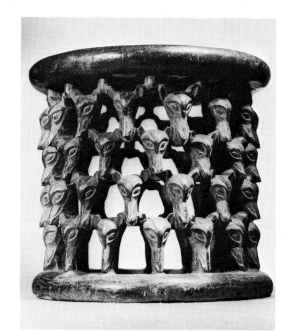

Bamenda Highlands carved wood
stool, 32.

Carvers at work.

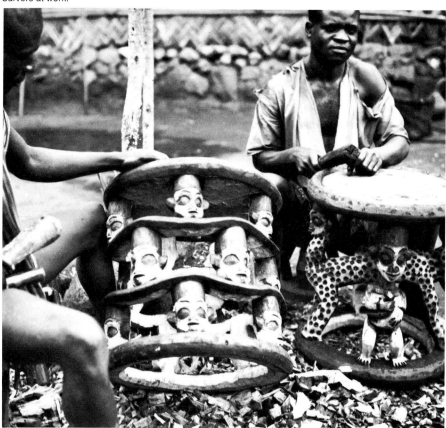

Their development from a plain, round-bottomed bowl into an ornamented, highly sophisticated object standing on a gracefully designed base, is an interesting one: In the course of this development a handle perfectly designed for both use and appearance is added on the side opposite the spout. Or rather, opposite where the spout had been; because in the same development the spout disappeared, leaving an ornament apparently needed as a balancing form for the handle—a function it performs handsomely.

Stools

Sculpture in the round reached its height in the royal stools of traditional society. Royal art is seen at its best in them. Each ruler had his own stool carved at the beginning of his reign to meet the demands of his lineage totem and to please his personal taste. The symbols of mythology abound here: leopard, python, lizard, chameleon, bat, earth spider. Human figures, especially women, are seen upholding the seated ruler; and rows of heads may indicate successful warfare. The sacred stool of the Cameroon corresponds somewhat to the idea of the royal throne in other cultures. Appointed keepers guarded these stools, gave them oil baths before festivities, treated them with utmost respect and allowed none but the sacred owner to occupy them. Death of the owner relegated stools to storage or disposal. Stools covered with glass beads, a by-product of slave trading, became popular in certain areas. The Bamum craftsmen enlarged on this art under the guidance of the late King Njoya and they developed geometrical designs for many other objects to meet the requirements of the Koran, to which they have been turning since 1900.

Textiles

Spinning and weaving of cotton, wool and other fibers into narrow strips of cloth, once a widespread practice, is now confined to the Northern area. These three to four inch strips were sewn together to make loincloths for the common man, gowns for the elite, and for the large tie-dyed hangings for prosperous rulers. These were used as backdrops when rulers sat in state at public showings. In some groups they also functioned as the basic unit of a dowry.

In the traditional division of labor, weaving and the tailoring of gowns and caps, as well as trading in textiles, was the prerogative of men.

Tobacco Pipes

This exhibition bespeaks the wealth of ideas and skill bestowed on

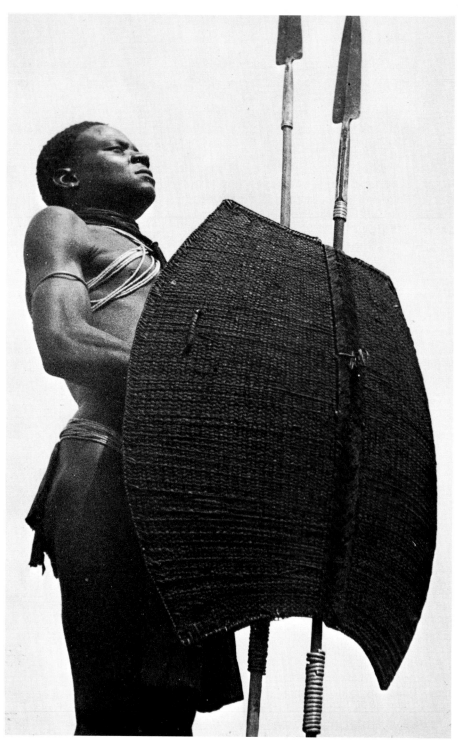

Northern Area Warrior with shield and spears.

man's status symbol, the pipe. It also displays the taste of the individual owner. Few are alike. The interchangeable parts allow for individuality in selection of bowls and stems.

Every art area developed pipes. But only two centers within two of the areas pushed their skill in forming the terra cotta pipebowls to a virtual monopoly: the Bangwa people in the Bamileke area and the Bamessing group in the Bamenda highlands. These two centers had the finest clay deposits, the best sculptors, and old trade routes at their command.

Though we collected these pipes in widely separated markets we can trace the origin of the bowl and stem design to one of the areas mentioned.

Transitional The word is used to describe that art being produced now which is no longer motivated by the religious and socio-political impulses of past tradition but still retains some of the skill and sense of design which formerly characterized the work.

Village Scenes It is not known who started casting the little groups of brass figures depicting Bamum village life. We know of pieces more than fifty years old and we are certain that King Njoya patronized the trend in order to please foreign visitors. The casting of miniature heads and figures—human and animal—is an old art of the Bamum. Some believe that in this old practice is found the origin of present casting of village scenes.

Weapons A conscious awareness of design is evident in the spears and shields. This grace of line and form transcends mere utility.

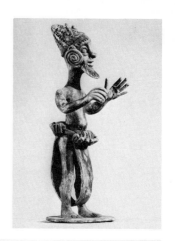

Bamum Area Figure, beeswax, 251.

Bamum Area Mask, cast brass, 401.

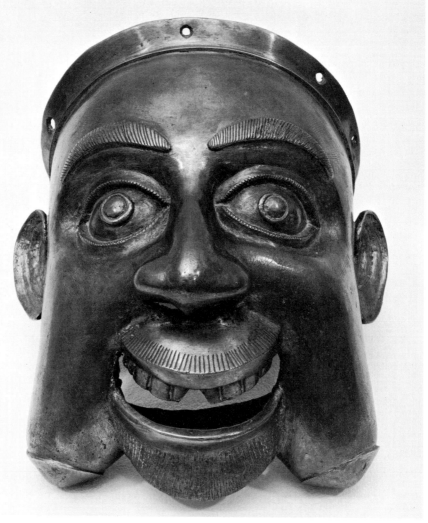

THE EXHIBITION

Works in the exhibition have been divided into the six regions represented in this portion of the Collection. Dr. Gebauer's inventory numbers have been used in the following listing.

BAMENDA HIGHLANDS

Helmet Masks: carved wood, 13, 17, 18, 19, 20, 81, 83, 84, 85, 87, 220, 231, 246, 257, 271.

Guardian Figures: wood, 51, 52, 55, 94, 95.

Seated Figure: wood, 400.

Pipes: terra cotta bowl, wood stem, 101, 107, 122, 126, 128; terra cotta bowl, wood and copper stem, 113; terra cotta bowl, wood and brass stem, 77, 114, 127; wood bowl, ivory and brass with copper wire stem, 172; wood bowl, ivory and brass stem, 173; wood bowl, ivory and copper stem, 174; terra cotta bowl, wood and iron stem, 364, 367.

Pipe Bowls: terra cotta prototypes, 70, 71, 133, 134, 135, 136; terra cotta, 102.

Charms: ivory, 36, 37, 38, 39, 40, 41, 93; wood, 42, 43, 44, 45, 46, 48, 49, 50, 96.

Stools: carved wood, 32, 59, 201, 203, 254, 265, 266, 314, 323, 384; fragment, 24.

Chief's Table: carved wood, 10.

Drink Horns: carved buffalo horn, 74, 75, 76, 181, 182, 183.

Elephant Tusks: carved ivory, 235, 307, 451, 452.

Architectural Sculpture: carved wood house posts, 1, 5, 6, 9; carved wood roof borders, 2, 3; carved wood roof support, 4; carved wood door posts, 7, 8.

Scepters: decorated and carved wood heads with horse tail trailer, 91, 92, 341.

Gongs: carved wood and iron, 148, 149, 150.

Ceremonial Food Paraphernalia: king's food bowl, wood, 23; food bowls, terra cotta, 132, 291, 292, 293, 294, 295, 296; gourd stand, 22; kola nut stand, 392.

Ceremonial Wearing Apparel: gowns, appliqued cotton, 475, 476, 477, 478; caps, fiber, 586, 587; caps, cotton applique, 479; caps, wool and cotton, 582, 583, 585; caps, cotton applique, 588, 589, 590, 591, 592; caps, cotton and feathers, 581, 584; dancing headgear, feather and fibers, 597, 598, 599.

Bags: woven fibers, 501, 502, 505, 506, 507, 509, 518; unfinished bags, 520, 521, 522; bag designs, 528, 529, 530.

Textile: cotton tie-dyed, 306.

Basketry: baskets, 26, 163, 350; basket with cowrie shells, 27; tray with cowrie shells, 35; trays, 348, 349, 354, 357; ring support, 595.

BAMILEKE

Helmet Masks: carved wood, with buffalo hide, 219; carved wood, 268, 304.

Figures: carved wood with brass bell and feathers, 97; carved wood, 212, 213, 214.

Pipes: terra cotta bowl, wood stem, 116, 138; terra cotta bowl, wood and copper wire stem, 69, 117; terra cotta bowl, bamboo stem, 118; wood bowl and stem, 129, 430, 453.

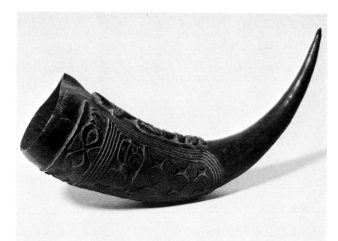

Bamum Area Drink Horn, Tungo Group, carved buffalo horn, 362.

Northern Area Funerary Trumpets, Tigong Group, carved wood, 99, 100.

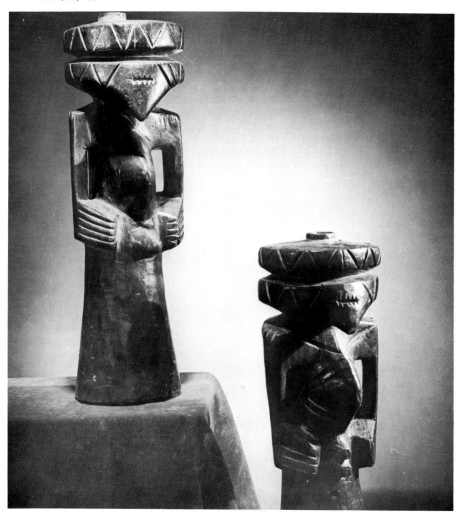

Pipe Bowls: terra cotta prototype, 139; terra cotta, 137; glazed terra cotta, 365, 369, 370; wood pipe bowl figures, 207, 252, 253, 468; cast brass, 313.

Drink Horns: cast bronze, 151; carved buffalo horn, 363.

Textiles: woven fibers decorated with geometric pattern, 562, 563. cotton tie-tied, 187.

Fly Whisk: wood, buffalo tail, 190.

BAMUM

Masks: carved wood, 218, 255, 308; cast brass, 158, 160, 393, 394, 401, 402, 406, 407; cast silver, 404.

Helmet Masks: carved wood, 11, 82, 226, 303, 305, 388.

Guardian Figures: carved wood, 95; beeswax, 251; wood, beads, seeds, cloth, 234.

Stools: carved wood, 202, 387.

Drink Horns: carved buffalo horn, 221, 362.

Pipes: terra cotta bowl, wood and copper stem, 112; terra cotta bowl, wood stem, 103, 110, 115, 120, 121, 123; terra cotta bowl, wood and iron stem, 119, 124, 130, 368; cast brass bowl and stem, 30; cast brass bowl, wood and iron stem, 161, 232.

Metal Sculpture: cast bronze necklaces, 311, 312; cast brass necklaces, 325, 461; cast brass lizard, 409; cast brass figurines, 410, 411; cast brass bell, 147; cast brass "Band of Ten," 154; cast brass "Group of Palm Wine Drinkers," 419.

Ceremonial Headdress: dyed fibers, 570.

Textiles: cotton tie-dyed cloth, 67, 187, 473; cotton, dyed and decorated cloths, 216, 217.

Container: gourd, decorated with glass beads and cowrie shells, 359.

MAMBILA

Helmet Masks: carved wood, 98, 205, 206, 236.

Guardian Figures: baked clay, 258; wood, 229, 233, 238, 239, 240, 241, 276, 277, 278, 279, 280, 281, 282, 337; pith, 224, 225, 283, 284, 285, 286, 287, 288, 289, 290, 328, 329, 333, 334, 335, 336, 360, 361.

Stool: carved wood, 250.

Weapons: iron spear blade, 455; woven raffia fiber shields, 222, 310; iron cutlass, 165.

Stoppers for Gourd Containers: carved and painted wood, 64, 65.

NORTHERN AREA

Helmet Mask: carved wood, 86.

Guardian Figures: wood, 9, 25, 78, 79, 80, 227, 228, 233, 237, 319, 326, 358; baked clay, 320, 321, 371.

Divination Figures: carved and painted wood, 88, 89.

Fertility Figures: carved and painted wood, 90, 146.

Funerary Trumpets: carved wood, 99, 100, 309.

Basketry: covered baskets, 344, 345, 346, 347; covers, 351, 352, 353, 356, 571, 572, 573; ring support, 594.

Mats: woven fiber, 469, 470, 471, 472.

Textiles: woven fiber costume, 188; batik cloth, 474; woven cotton runner, 481; blankets, 483, 484.

Jugs: terra cotta 131; terra cotta fragment, 170.

Bowls: wood palm oil bowl, 223; dried gourd milk bowl, 600.

Stools: carved wood, 21, 171.

Metalwork: necklace, 465; collection of seven necklaces, 466; pair of anklets, 467.

Weapons: iron spear blades, 454, 456, 457; iron spear blade and wood shaft, 458; spears, iron and wood, 459, 460; cutlasses, iron and wood, 164, 262; woven fiber sheath, 144.

Currency Plate: iron, 143.

**TRANSITIONAL
Bamum Area**

Metal Sculpture: cast brass, "Bamenda Highland Settlement," 50 pieces, 412; "Northern Settlement," 34 pieces, 413; "The Queen's Procession," 8 pieces, 414; "The King's Parade," 20 pieces, 415; "The Fumban City Gate," 5 pieces, 416; "Farming Women," 11 pieces, 417; "Palm Wine Party," 4 pieces, 418; group of three brass figures, 424; "Maize Beer Brewery," 464.

Textiles: blue cotton prints, 485, 486.

Relief Carvings: carved wood plaques, 301, 302.

WIDEKUM

Masks: carved wood, 14, 15, 318, 339, 340.

Helmet Masks: carved wood, 249, 391.

Ceremonial Headdresses: carved and painted wood, moveable joints, 198, 327; carved wood, 16.

Spoon: carved and polished wood, 482.

Battle Standard: carved wood, 248.

Loincloths: woven fibers, 551, 552.

Design: Lynch & Van Cleve Associates
Photos: Dr. Paul Gebauer and Alfred A. Monner
Printed at Graphic Arts Center